ECLIPSE

ECLIPSE

KELSEY OSEID

OUR SKY'S MOST
DAZZLING PHENOMENON

TEN SPEED PRESS
California | New York

CONTENTS

PROLOGUE

Imagine standing on a hilltop on a clear, sunny day. You're surrounded by scattered groups of people, all with their eyes trained on the sky, wearing custom super-dark glasses for protection. You're all anticipating the same thing: a total solar eclipse.

You've all been waiting for a good hour since the moon first began to inch across the face of the sun, as if a bite were being taken out of that brilliant disk. (This slow procession is why many of the observers have brought deck chairs, to watch and wait in comfort!) This is the partial phase of the eclipse, when the moon covers some of the sun, but not all. And that's all that most observers in a much wider area will see, unless they've purposely placed themselves under the narrow band of totality.

The minutes tiptoe by as the moon tiptoes on. Finally, the sun looks like a crescent, the shape of a cartoon moon. You peek at the sun only with your protective shades on, then take them off to observe the surrounding changes. The light is growing dimmer, approaching a kind of twilight, and the air is starting to cool—you may reach for a jacket or sweater. The environment quiets, oddly, and you realize the birds have stopped chirping—they may even go to roost. Other

animals (livestock, pets, and wild creatures like deer) are disconcerted, restless; they're unsure of what is happening, but something is definitely wrong.

One observer jumps to their feet and points to the distant landscape. From up on the hill, you can see it too: the vast dark shadow of the moon racing toward you, heralding totality. With the sun at last fully covered, it's safe to remove your protective glasses—then, transfixed, you and your neighbors stare. The sun is gone, and in its place, a supernatural sight. A dark hole cut out of the daytime sky, surrounded by a glowing wreath of energy. For first-time viewers, it's like nothing they've ever seen before. The sun, moon, and Earth are perfectly aligned; the sun's glowing corona is visible for the rarest of moments around the black disk of the moon, and planets and stars are revealed in the daytime sky.

But totality is fleeting. You've carefully timed the safe window for naked-eye viewing (and photography), and before the moon releases a fiery edge of the sun, you put your protective glasses back on. You watch the sequence in reverse, and finally it's over. And you immediately wonder: When can I see another one?

INTRODUCTION

Ancient cultures imparted a higher meaning to the phenomenal celestial events that are eclipses. How could they not? When the sun disappears in the middle of the day, or when a vast shadow bathes the moon in a bloodred glow, who could resist drawing the conclusion that something bigger is going on?

At one time we believed in mythical beasts swallowing the sun whole, angry gods turning the moon crimson to signal earthly impending doom . . . But in the modern world, with our ability to predict when eclipses will occur and our knowledge of the mechanisms making them possible, the meaning of eclipses has flipped. Instead of signaling something wrong—Where is the sun going? What is happening to the moon?—they show us that everything's working just as we expect it to (an eclipse, right on time!).

Since early in our human consciousness, there have been two celestial bodies that most Earth dwellers can observe and that behave predictably on a daily basis: the sun and the moon. In fact, the brighter of the two—the sun—was the very basis *of* the day. In the mornings, the sun rose in the east. By nighttime it had traveled across the sky and set in the west. The moon was a little more changeable, since as it passed through its phases its appearance transformed, little by little each day, but this cycle takes only about 29.5 days and is easily tracked. While the moon did seem to disappear once each cycle, during the new moon phase, this was eased into over several days and was considered predictable very early in human history. (Humans tracked the moon through its phases as early as thirty thousand years ago, as evidenced by ancient lunar calendars etched into animal bones.)

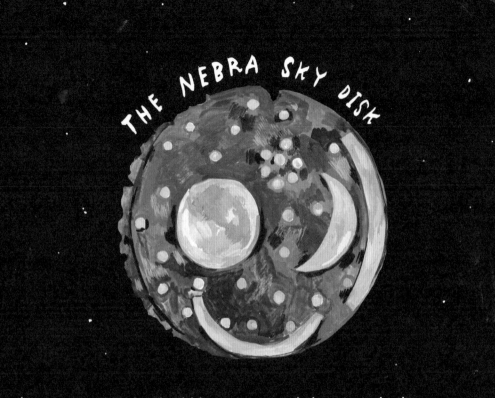

THE NEBRA SKY DISK

The Nebra Sky Disk is a testament to the important roles the celestial bodies played in the lives of our ancestors. Dating back to 1600 BCE or possibly earlier, the foot-wide bronze disk contains depictions of the sun and stars, as well as coded references to the timing and location of the setting of the sun in the region of modern-day Germany where the disk was found. The crescent shape is variously thought to depict a phase of the moon or a solar eclipse.

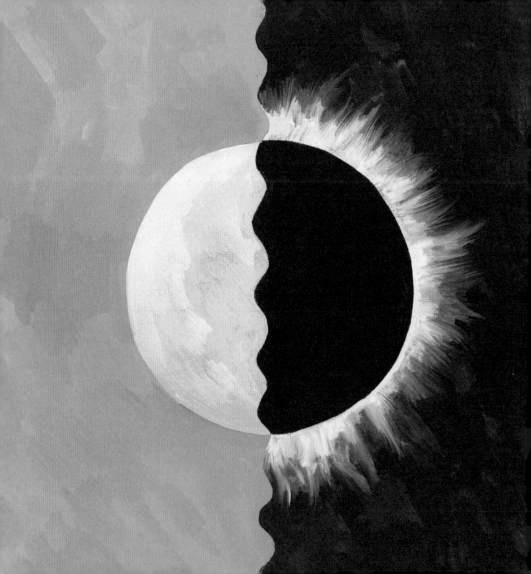

Eclipses, unlike moon phases, seemed so unpredictable as to be random. Confounding factors like weather (it is harder or even impossible to see a lunar eclipse on a cloudy night, for instance) and geographic location (many total solar eclipses are visible only from very particular places on Earth, and sometimes in the middle of the ocean where there's no one to see them at all) would have made eclipses seem even more random, more extraordinary—and more ominous. And unlike the phases of the moon, happening gradually over the course of the month, eclipses were sudden. A solar eclipse looked like a vicious bite was being taken out of the disk of the sun, seemingly out of nowhere, and a bloodred lunar eclipse dimmed the moon on the very night it was at its fullest. The apparent randomness was all the more ominous when it seemed to threaten the otherwise comfortably predictable motions of the heavens.

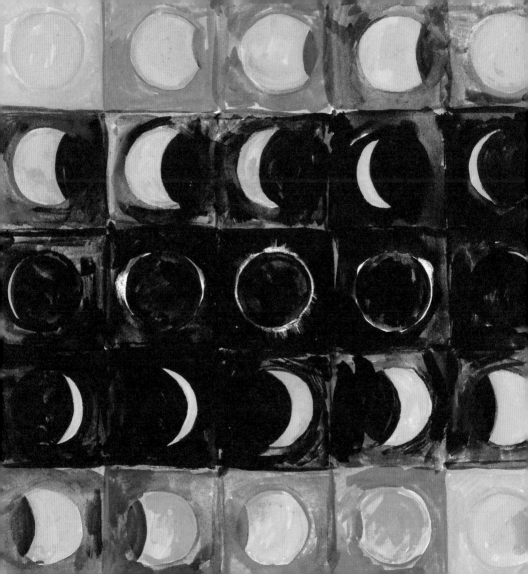

The exceptional strangeness of eclipses and the intense emotional reactions they evoke are probably what motivated many ancient cultures to keep careful records of them. The ancient Mesopotamians kept such records; they are credited with observing and spreading the knowledge of the way eclipses recur periodically. For although eclipses do not occur on a daily basis, like the rising of the sun, or a monthly one, like the phases of the moon, they do follow a pattern. They turn out to more or less repeat on a cycle of 223 synodic months (that is, lunar months, measured from one new moon to the next), or about eighteen years and eleven days, which is sometimes called the saros cycle; this unit of time is one saros. Every saros, or approximately every 6,585 days, a nearly identical eclipse will occur, in which Planet Earth aligns with the sun and moon in almost the same way, and the eclipse takes place along the same geographical path.

A moment-by-moment depiction of a solar eclipse is reminiscent of a night-by-night depiction of the phases of the moon.

It was not necessary for the ancients to understand the shape of the solar system or even that the Earth was not at its center in order to use this cycle. But understanding of the saros cycle began to chip away at the notion of eclipses as bad omens. As time went on, astronomers devised endlessly convoluted models of the sky in an attempt to further explain the motions of the heavens—models that were unnecessarily complicated in order to justify what was going on in the sky. By the eighteenth century, humans had moved from a general belief in a geocentric model of the universe (with Earth at its center)—famously championed by Claudius Ptolemy—to the Copernican heliocentric model (with the sun at the center of the solar system). The motions of the heavenly bodies became settled fact in the common astronomical understanding. Math could now be used to predict the relative positions of the sun, moon, and Earth.

And so, with increasing accuracy over time, astronomers were able to calculate the precise dates, times, locations, and characteristics of future eclipses. Today, sophisticated calculations make it possible to spin out eclipse predictions, accurate to the second, for millennia into the future.

Retrodicting is the practice of calculating eclipses that happened in the past; it can be used to link accounts of eclipses in art, religion, literature, and history with their celestial backdrop.

ECLIPSES IN MYTH

While we now understand why eclipses happen, the emotional response felt by our ancestors lingers. Totality—the phase during a total solar eclipse in which the sun is completely obscured by the moon, and its feathery corona is revealed—is described as an unparalleled experience of earthliness, equal parts weird, majestic, frightening, and invigorating. Total solar eclipses and their siblings, partial and annular solar eclipses, bring us outdoors, gathering with our protective eyewear to see the rare phenomena. Lunar eclipses, more widely visible and safe to view with the naked eye, serve as colorful reminders of the shape of our own Earth as we see its round shadow projected onto the moon.

Did ancient cultures believe the sun and moon were *literally* being eaten? Or is it us, in modern times, who are less equipped than ever to see natural wonders as anything other than literal? In today's mainstream cultures, we don't tend to view the universe with the animism of the ancients. But even today, when we know exactly when and why eclipses occur, people describe seeing one as a mystical experience. We don't bang pots and pans to scare away a dragon, but eclipses still draw us out of our homes, donning weird-looking solar goggles, waiting for the sun to disappear, and shrieking with wonder when it does. Are we really so different from our ancestral eclipse-viewers?

In myths across cultures, the sun and moon are depicted as lovers, meeting only in the darkness of a total solar eclipse so that we cannot watch their rare union. Sometimes the relationship is depicted as a predatory one, with the sun aggressively chasing the moon, or vice versa. Other times they appear as rivals: The moon dares to step in front of the sun, and the sun responds by displaying a greater majesty than ever before.

In Korean mythology, it was thought
that fire dogs took bites out of the sun and
moon during solar and lunar eclipses.

In Chinese mythology, dragons were said to eat the sun and moon.

In an ancient Vedic text, an earthly demon traps the sun, turning the world dark during a solar eclipse.

In Norse mythology, it was thought that eclipses resulted from the sky wolves Sköll and Hati pursuing the sun and moon, respectively.

SUN
864,000 MILES / 1,392,000 KM
IN DIAMETER

EARTH
7,917 MILES / 12,742 KM
IN DIAMETER

MOON
2,159 MILES / 3,475 KM
IN DIAMETER

RELATIVE SIZES

COSMIC COINCIDENCE

Eclipses happen only as the result of a truly spectacular coincidence: that of the disk sizes of the sun and moon. "Disk size" describes the apparent size of celestial bodies in our sky as viewed from Earth. The diameter of the sun is around four hundred times that of the moon, and the distance between the sun and the Earth is around four hundred times the distance between the moon and the Earth. This means the apparent sizes of the sun and the moon in our sky are nearly identical. There's no scientific reason for this—it's simply a coincidence.

The sun is approximately 864,000 miles (1,392,000 km) in diameter and on average is around 93,000,000 miles (150,000,000 km) from Earth. The moon is approximately 2,159 miles (3,475 km) in diameter, and it orbits Earth at an average distance of 238,000 miles (383,500 km). Note that the distances between these bodies are not constant. Both Earth's orbit around the sun and the moon's orbit around Earth are not perfectly circular, but slightly elliptical, and the orbits even speed up and slow down at different points. Even the bodies themselves are not perfectly spherical. These fluctuations in the relative distances between the sun, moon, and Earth, and even their irregular sizes, account for some of the variation in the types of eclipse that we will discuss later.

Of the more than two hundred moons in our solar system, our moon is the fifth largest, after Jupiter's Ganymede, Saturn's Titan, and Jupiter's Callisto and Io. The ratio of our moon to Planet Earth is larger than that of any other planetary moon in our solar system.

GANYMEDE　　TITAN　　CALLISTO　　IO　　OUR MOON

Where did the sun and moon come from? Our sun, currently classified as a yellow dwarf star (even though its light is actually white), began its life as a cloudy presolar nebula. Around 4.6 billion years ago, this cloud collapsed and transformed into the ball of plasma it is today. The collapse also formed the circular plane of planets orbiting the sun. Our moon came into being around that time too, but we still don't know exactly how. One theory, the giant-impact hypothesis, describes an ancient planet colliding with the early Earth, sending debris into Earth's orbit, where the fragments merged together, forming the moon. For the purposes of this scenario, astronomers have named the hypothetical impact planet Theia, after the Titan of Greek mythology. Perhaps we have Theia to thank for the sublime coincidence of disk sizes.

We are fortunate to live in a period when total solar eclipses still occur—this won't last forever. Because the moon is gradually drifting farther from the Earth in its orbit (albeit very gradually—less than two inches a year), eventually its disk size will no longer be large enough to fully eclipse the sun. Luckily for us, that won't happen for more than another six million years. But still, doesn't it feel more special now that you know someday it will end?

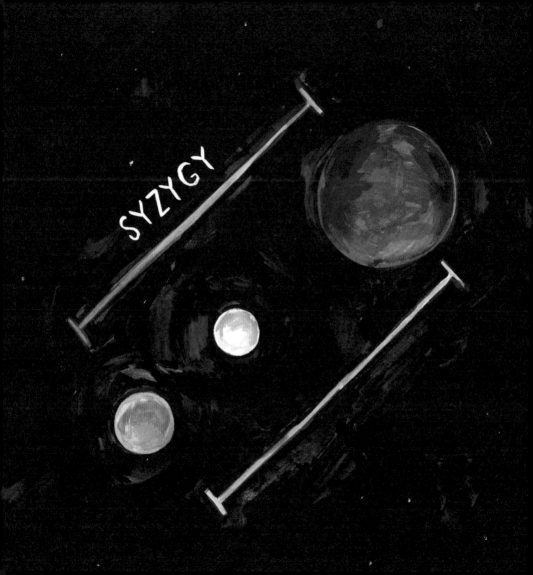

ECLIPSES 101

An astronomical alignment of three bodies has the unusual name **syzygy**, from the ancient Greek for "yoked together." Both solar and lunar eclipses are syzygies of the sun, moon, and Earth. Each year, some two to five solar eclipses of one kind or another take place, in addition to two or so lunar eclipses. Whether these are visible depends, as previously mentioned, on countless terrestrial factors, with local weather and geography being the most significant. A **total solar eclipse** happens around every eighteen months, but because an eclipse's entire path can fall on uninhabited land or sea, not all are easily seen. Some are **point eclipses**, visible from only a tiny spot on the Earth's surface—if this happens to fall on parts of Antarctica, or in the middle of the ocean, it's yet another eclipse that almost no human is likely to witness.

SOLAR ECLIPSE
SUN MOON EARTH

LUNAR ECLIPSE
SUN EARTH MOON

When one celestial body passes in front of but does not fully obscure another, its passage is known as a **transit**. Partial solar eclipses belong to this category. When a celestial body passes in front of and does fully obscure another, it is known as an **occultation**. Occultations occur during total solar eclipses. In lunar eclipses, we do not witness firsthand either a transit or an occultation, because we are watching from the Earth, but if there were viewers on the moon during a lunar eclipse, they would see a transit or occultation of the sun by the Earth.

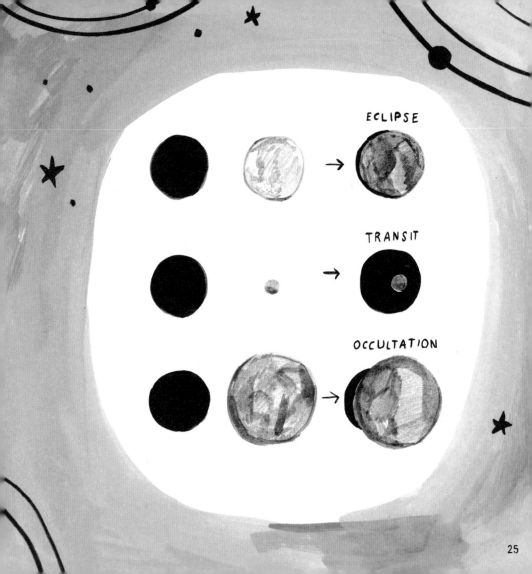

ECLIPSE

TRANSIT

OCCULTATION

25

In both solar and lunar eclipses, we are concerned with the shadows cast by the sun. In a solar eclipse, the moon is directly between the sun and the Earth, and the sun casts the moon's shadow onto the Earth. Depending on our location, we on the Earth's surface can be cast into darkness as that shadow passes over us (from the appropriate vantage point, we may also observe it sweeping across the landscape as it approaches us just before totality).

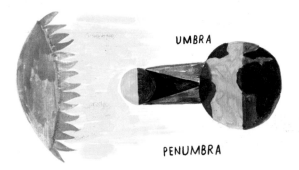

UMBRA

PENUMBRA

During a lunar eclipse, the Earth is directly between the sun and moon, and we see the shadow of the Earth cast onto the moon. There are two types of shadow: **umbra** and **penumbra**. The umbra is the darkest portion at the center of the cast shadow. With increased distance, the cast umbra gets smaller and smaller. Penumbra is the more diffuse shadow surrounding the umbra. With increased distance, the cast penumbra gets larger and larger.

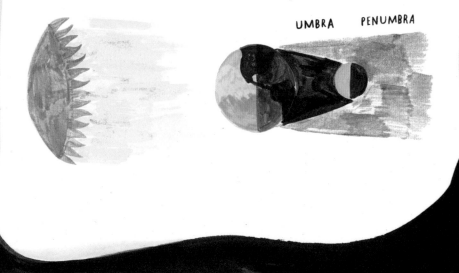

UMBRA PENUMBRA

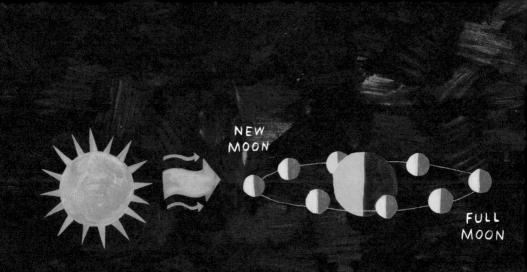

NEW MOON

FULL MOON

A solar eclipse can occur only at new moon (when the lunar disk as seen from Earth is in total darkness), because that's the only time the moon will pass between the sun and the Earth. A lunar eclipse can occur only at full moon, the only time the Earth passes between the sun and moon. But we don't see a solar eclipse every new moon, nor a lunar eclipse every full moon. If the solar system were arrayed in a perfectly flat disk and its bodies perfectly orderly, we would. But although that's how it's generally depicted and imagined, the solar system is not perfectly flat and not perfectly even.

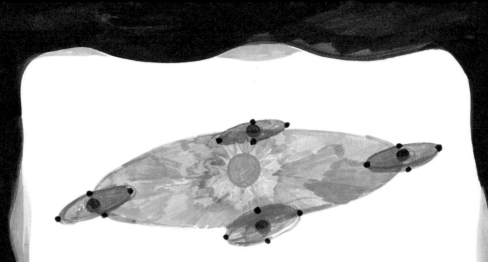

The main factor making eclipses uncommon is that the plane of the moon's orbit around the Earth is tilted by 5 degrees with respect to the plane of the Earth's orbit of the sun. A small enough amount, but with an outsized impact on the frequency of eclipses. So eclipses can occur only at or near **nodes**—the spots where the moon's orbit around the Earth intersects the plane of the Earth's orbit around the sun.

Part of what makes eclipses so weird is the way they require us to hold two conflicting realities in our minds at once: the true reality of a three-dimensional solar system and the illusion of a flat, two-dimensional sky. Early globe makers created something called a pocket globe that illustrates well the concept of a flat, two-dimensional sky. A small terrestrial globe, painted with the land and sea of the Earth, was created to fit perfectly inside a jointed spherical case. On the inside surface of the case were the night sky, stars, and other celestial elements, like illustrated constellations, as we see them from Earth.

A pocket globe

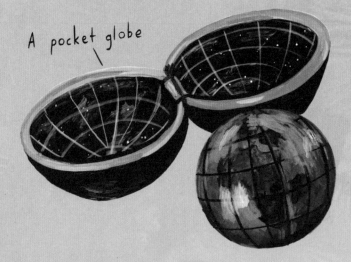

Sometimes when we talk about eclipses, we speak of them in terms of that flat surface—for instance, when we say that a lunar eclipse is taking place "in the constellation Leo." This means the sun will cast the Earth's shadow onto the moon while the moon is passing the region of the two-dimensional sky designated as the constellation Leo. Of course, we are not saying that the lunar eclipse is somehow happening within the actual location of the stars of a constellation in three-dimensional space. Stars within any given constellation aren't necessarily anywhere near even each other. Constellations are mostly just a geocentric way of referring to what we see in the night sky.

A lunar eclipse "in" the constellation Leo.

Did you know that the Earth doesn't orbit the sun at a constant speed? It actually speeds up and slows down based on how close it is to the sun, which is variable because the orbit we make around the sun is an ellipse, not a perfect circle. We don't maintain the same distance from the sun in our orbit—that distance can vary by as much as 3 percent (a difference of millions of miles). When we are closest to the sun, we are at **perihelion**, and when we are farthest away, we are at **aphelion**.

The distance between the moon and Earth varies too. When the moon is closest to us, it is at **perigee**. When it is farthest from us, it is at **apogee**. From perigee to apogee, the moon's distance from Earth can vary by 12 percent. That means its disk size, depending on its location, varies quite widely too, from perceivably smaller than the sun's to quite a bit larger. (Of course, the moon itself is not changing size—just the apparent disk of the moon on the celestial sphere.) These variations account for the differences between total and annular eclipses of the sun, which we'll discuss later (see page 42).

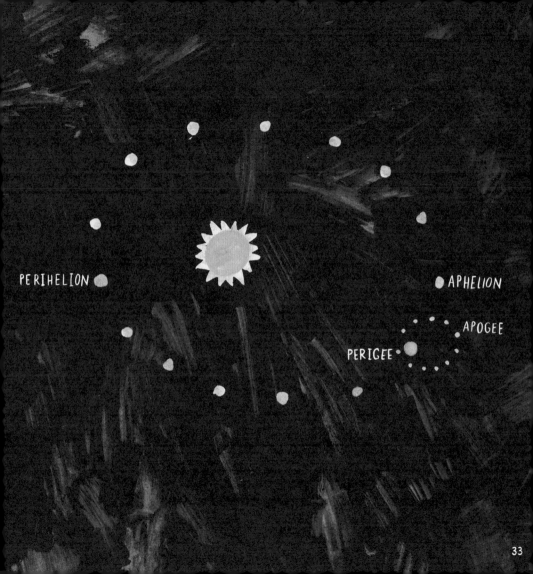

PERIHELION

APHELION

APOGEE

PERIGEE

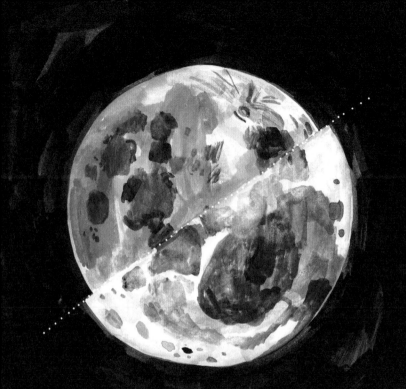

A **supermoon** is the popular name for
the full phase of the moon when it is
at its closest to Earth (at its perigee).
The disk of the moon appears a little
bit brighter and a little bit larger
during a supermoon.

Thus the solar system's concentric formation is not a geometrically perfect circular plane, but a moving, interacting system of countless bodies orbiting one another. Even our moon, with its mostly regular cycles, is not without its wobbles. The gravitational tug of the sun on the moon affects its movement, as do the other planets in our solar system. We are one teeming mass of bodies pulling on one another in so many ways.

Though the differences might be minuscule and even invisible to the naked eye, little tiny fluctuations in movement and timing add up to more and more complicated math that is required to predict eclipses with any accuracy. There are regular patterns to eclipses, but the closer we look, the harder they are to see without that sophisticated math. Zooming back to the entire scale of recorded human history, the patterns are there, and they continue on into the future.

ECLIPSES THROUGH THE AGES

NOVEMBER 30, 3340 BCE

2136 BCE to 2128 BCE

MAY 3, 1375 BCE

Spiral-shaped petroglyphs at the megalithic Loughcrew Cairns in Ireland may reference the solar eclipse that took place on this date.

A solar eclipse referenced in the ancient Chinese text called the *Shujing* probably took place in this time period. The *Shujing* verse reads "the Sun and Moon did not meet harmoniously in Fang," also referencing an astronomical zone of the night sky.

A total solar eclipse from this date is recorded on Babylonian clay tablets. During the next millennium, Babylonian astronomers and their successors continued a tradition of recordkeeping that led to the discovery of the saros cycle.

Approximately
1281 BCE

585 BCE

29 CE to 33 CE

An ancient Chinese oracle bone from around this time is thought to reference a total solar eclipse. A translation reads "three flames ate up the sun, and a great star was visible."

Thales of Miletus, a mathematician of ancient Greece, is often said to have been the first person to predict an eclipse, a total solar in 585 BCE. This story is probably untrue; Thales's predictive method was never used again, and if he managed to predict the eclipse at all, it's likely he was just lucky. Much of eclipse lore is apocryphal!

A number of eclipses during this period, both lunar and solar, are associated with the crucifixion of Jesus recounted in the Bible (but none conclusively so).

Between 150 and 170 CE

1200s CE

The *Almagest*, Claudius Ptolemy's landmark treatise on astronomy, describes eclipses and proposes a method for their prediction. From that point on, more and more eclipses are predicted, and they are increasingly viewed with interest instead of fear.

The Mayan tome now referred to as the Dresden Codex gives tables for predicting lunar and solar eclipses. Though this hieroglyphic text was probably assembled in the thirteenth century, it is thought to be a copy of a text from several centuries earlier.

JULY 28, 1851

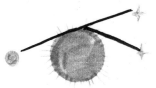

MAY 29, 1919

First successful photograph of a total solar eclipse. As photography improved over the next century, it led to more sophisticated eclipse discoveries, such as the revelation that the corona was part of the sun, not the moon. (Time-lapse photos revealed that it did not move along with the moon during the course of totality, but remained anchored to the disk of the sun.)

Einstein's theory of general relativity is proven by measurements of stars visible during totality. The displacement of the apparent positions of the stars matched Einstein's predictions. The light from the stars was bent by the gravity of the sun; this discovery propelled Einstein and his theory to widespread recognition and acceptance.

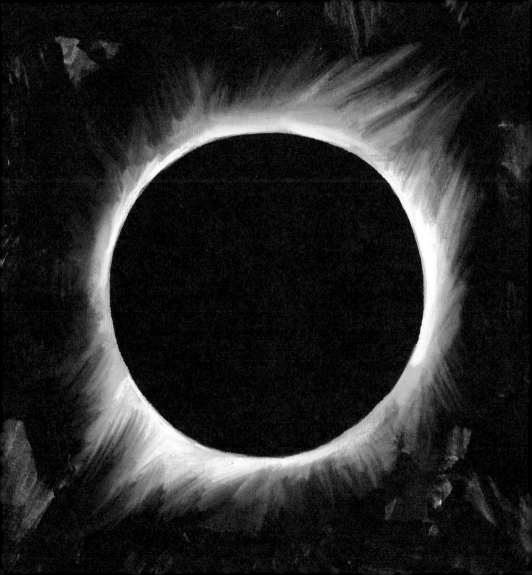

SOLAR ECLIPSES

Between lunar and solar eclipses, the latter tend to elicit far more excitement. They're dramatic, especially when most or all of the disk of the sun is obscured. They're also a rarer sight, since they're visible from only a narrow sliver of the Earth.

TYPES OF SOLAR ECLIPSES

There are three main categories of solar eclipses: total, partial, and annular.

Total solar eclipses are far and away the holy grail of eclipse watching. These take place when the disk of the moon completely occludes the disk of the sun. We call the period of total eclipse **totality**. Totality is the only time we can see the sun's corona. A time-lapse of the sun moving through the sky during a total solar eclipse gives us just a small hint of how singular the few minutes of totality are: we can see that the partial eclipsing is indeed a spectacle, but it doesn't convey how the entire sky flips from day to night during totality. It's like no other phenomena we can experience on Earth. Total eclipses of the sun are visible only from within the thin path of the moon's umbra, also known as the **path of totality**. To view totality, you must stand within this path—sometimes only tens of miles across. Standing slightly outside of it, you'll see only a partial eclipse instead. During a total solar eclipse, different locations experience different lengths of totality.

TOTAL
solar
eclipse

PARTIAL
solar
eclipse

ANNULAR
solar
eclipse

The center line of the umbra is where you need to position yourself if you want to maximize experiencing totality. The spherical moon casts a circular shadow on the Earth; locations on the line through the direct center of this circle's path necessarily spend the longest possible time in shadow.

We often speak of the paths of eclipses as being drawn across the globe, but as with the paths traced by our rising and setting sun and moon, the apparent motion is misleading; it's actually the spinning of the rotating Earth that draws out those paths.

CENTER LINE OF UMBRA

PATH OF TOTALITY

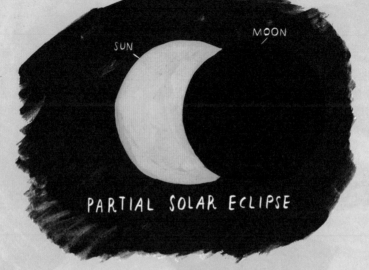

SUN
MOON

PARTIAL SOLAR ECLIPSE

Partial solar eclipses occur when the disk of the moon partially occludes the disk of the sun. They are seen from within the penumbra of the moon—the wider band around the umbra. A partial eclipse can be seen by viewers who are outside the path of totality but still inside the penumbral path of the moon. Partial eclipses are not always connected to total eclipses—they can occur on their own even when totality will not take place on the Earth's surface, when the penumbra but not the umbra falls on the surface of the Earth.

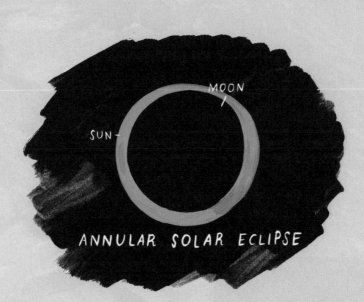

SUN

MOON

ANNULAR SOLAR ECLIPSE

Because the moon's orbit is elliptical, the moon is sometimes far enough away that it can't fully eclipse the sun. **Annular solar eclipses** occur when the disk of the moon is too small in the sky to fully obscure the disk of the sun, but align such that an **antumbral** shadow does cross over the surface of the Earth. These are sometimes called ring of fire eclipses. The path the antumbral shadow traces across the Earth, from which an annular eclipse is visible, is called the **path of annularity.** On either side of this path a partial eclipse will be visible.

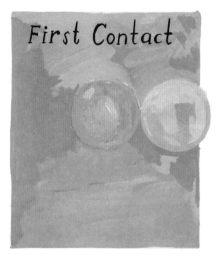

First Contact

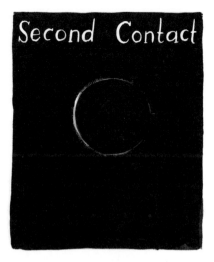

Second Contact

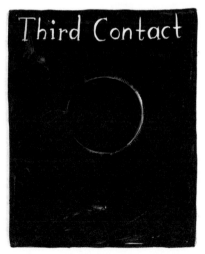

Third Contact

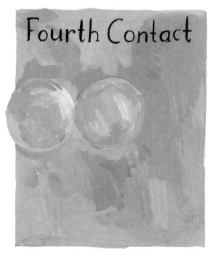

Fourth Contact

CONTACT IN SOLAR ECLIPSES

Four moments of **contact** occur during an eclipse. In a total solar eclipse, **first contact** happens at the beginning of the partial phase, the instant the edge of the disk of the moon moves over the edge of the disk of the sun. **Second contact** happens the instant the disk of the moon fully occludes the disk of the sun—the start of totality. (In an annular eclipse, the start of annularity is also called second contact.) **Third contact** occurs at the end of totality (or annularity), and **fourth contact** occurs the moment the partial phase ends, the instant before the disk of the moon finishes crossing the disk of the sun.

Occasional accounts (sprinkled throughout history and including a passage of the Bible) speak of the sun holding still in the sky or even momentarily reversing its course during a solar eclipse. These stories probably stem from an optical illusion related to the speed of the lunar disk overtaking that of the sun (sort of like the feeling that your parked car is moving forward when the car beside you reverses out of their spot).

VISUAL COMPONENTS

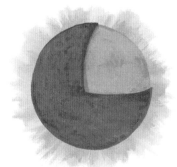

The part of the sun we can usually see—what we often call the "surface" of the sun—is called the **photosphere**. It is blindingly bright, so much so that it outcompetes another emittance of light: a part of the sun's atmosphere called the **chromosphere**. This is visible to us earthbound viewers for only a brief moment at the start and end of totality during a total solar eclipse, when the photosphere is masked by the silhouette of the moon. The chromosphere is only a few thousand miles thick, a very thin layer around the sun, and it can appear briefly as a narrow red ring of light during a total solar eclipse.

Gas spikes that eject from the sun, called prominences, are another special eclipse sight.

THE CORONA

The **corona** is the largest feature of a total solar eclipse. This is the crown of light extending from the sun on all sides from behind the lunar disk. It is visible only during totality because it is normally far outshone by the photosphere, but when the photosphere is blocked, we can see it. At millions of degrees (measured in either Fahrenheit or Celsius), the corona is actually far hotter than the photosphere, but also far more diffuse.

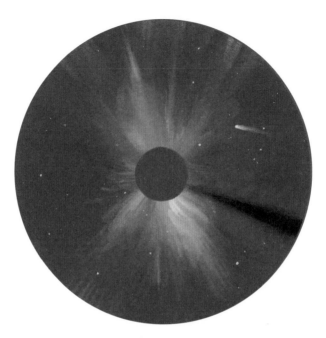

A **coronagraph** is a telescope with its own built-in obscuration to create an artificial eclipse; this can reveal the corona for documentation. Coronagraphs are far more effective when used outside the distorting visual influence of the Earth's atmosphere, so they are often attached to satellites for long-distance imaging.

SOLAR ECLIPSE PHENOMENA

The edge of the lunar disk is not perfectly smooth; the moon's mountains, valleys, and craters create variations. Usually these variations are imperceptible to the naked eye—viewers on Earth are too far from the moon to make out any imperfections in the otherwise circular disk. But during total and annular solar eclipses, the varied edge of the moon makes itself known via a glittering effect known as **Baily's beads** (named for nineteenth-century astronomer Francis Baily, who first explained the nature of the effect). Just as the disk of the moon is about to reach its maximum coverage of the disk of the sun, the final rays of sunlight glimmer through the crevices of the moon's textured surface. From Earth, the glinting lights appear as luminous beads on a perfectly round ring (the round border drawn by the sun's corona).

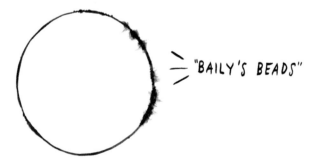

"BAILY'S BEADS"

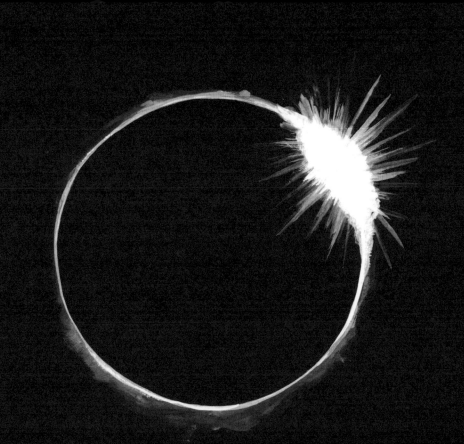

Right before and right after totality, one of these beads can gleam bright on the edge of the ring of the sun—this is called **the diamond ring effect.**

Down on Earth, as the moon approaches totality, the air grows cooler, as the warming rays of the sun are obscured and the light begins to dim. Before and during totality, animals' behavior changes. Anecdotal accounts from all over the world report livestock heading back into the barn, believing nighttime has suddenly fallen. Dogs are said to become transfixed by the rapidly changing sky. Studies have shown that birds in flight land en masse as the lunar disk moves over the disk of the sun.

Shadow bands often shimmer across the landscape right before (and after) totality. These waving stripes of shadow are refractive effects from the atmosphere of our own Earth. In one account of a 1925 total solar eclipse, these were described as the "gossamer scarfs" of fairies.

SAFETY

One problem of our modern culture is an increasing orientation to an indoor life, which carries with it a tendency to fear nature, as it becomes more and more foreign to our daily lives. Knowing that some berries and mushrooms can be poisonous, we may not even try to learn which wild ones are edible; we just stick to the supermarket.

Sadly, this disconnect and the trepidation it brings extends to the astronomical in the case of eclipses. There are stories of entire towns full of people locking themselves inside their homes on eclipse day for fear of their eyes being damaged by the mere existence of the eclipsing sun in the sky. Don't let this happen to you! The magic of experiencing an eclipse is not to be missed, so long as you are aware of some basic safety precautions.

Never look directly at the sun (during an eclipse, or ever, actually); also, do not try to view it with magnification devices like binoculars. Eye protection is always required to prevent eye damage when observing a solar eclipse. The one exception is the period of totality, when the entire disk of the sun is blocked from view by the moon. Make sure you are thoroughly familiar with the timing of your eclipse's period of totality, so you know when to look away or put your eye protection back in place. Note that there is no such safe period during a partial

or annular eclipse. During those solar eclipses, and during every part of total solar eclipses besides totality, specialized eyewear is essential to observe the eclipsing sun. Contact your local science institution for information on where to find appropriate eyewear. Don't try homemade filters like smoked glass (which used to be a common tool for eclipse viewing but was never safe). Check with the experts instead—many science museums and planetariums will sell or even hand out free solar filters and/or eclipse glasses.

In lieu of eclipse glasses, you can always use a pinhole camera to safely view a partial eclipse. A pinhole camera is an excellent, easily assembled tool you can make by punching a small hole through a piece of cardboard or paper. If you hold this out at arm's length, it will project an inverted image of the eclipse's crescent onto the ground or whatever flat surface you are near. The tenth-century astronomer Ḥasan Ibn al-Haytham expounded on the usefulness of pinhole projections for viewing eclipses safely—this is probably the only centuries-old eclipse-watching trick that actually protects your eyes!

Sometimes the spaces between leaves in the trees cast little pinhole images of solar eclipses onto the ground.

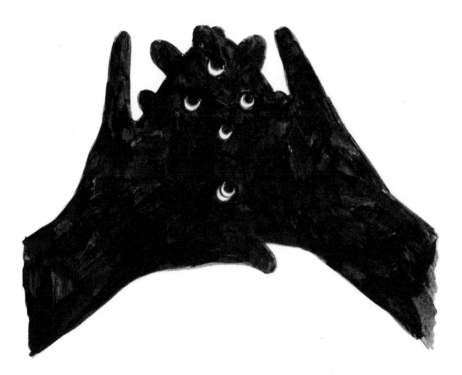

If you've forgotten to bring one from home, you can make your own with no materials at all by crossing the extended fingers of one hand over the other near the flattest surface available—your own body will cast a little grid of images of the crescent onto the sidewalk, your friend's shirt, your own lap, and so on.

It is safe to look at all types of lunar eclipses without protective eyewear.

ECLIPSE CHASERS

These days, people spend hours and even days traveling by foot, car, train, and plane to any corner of the Earth from which a total solar eclipse will be visible. Even eclipses that wouldn't normally be seen by anyone—those whose paths of totality cross over only uninhabited open ocean—are now accessible via "eclipse cruises," in which cruise ships take a full complement of tourists out into the ocean to meet the path of totality. There are commercial flights scheduled to bring eclipse chasers above the pesky cloud cover for an unimpeded view of a total eclipse—including a high vantage point from which to watch the approaching shadow of the moon as it rushes toward them. On many occasions, eclipse chasers have actually convinced airline officials to move departure times by a number of minutes to ensure that the flight meets totality! The record for the longest time spent in totality is held by a crew of scientists aboard the supersonic jet called the Concorde. In the 1970s, an early iteration of the Concorde was modified to include special porthole windows and observational technology, and it maintained a view of totality for those aboard that lasted seventy-four minutes.

Any one spot on Earth is likely
to see a total solar eclipse only
once about every four centuries,
so this experience is not for the
stationary—it must be sought out.

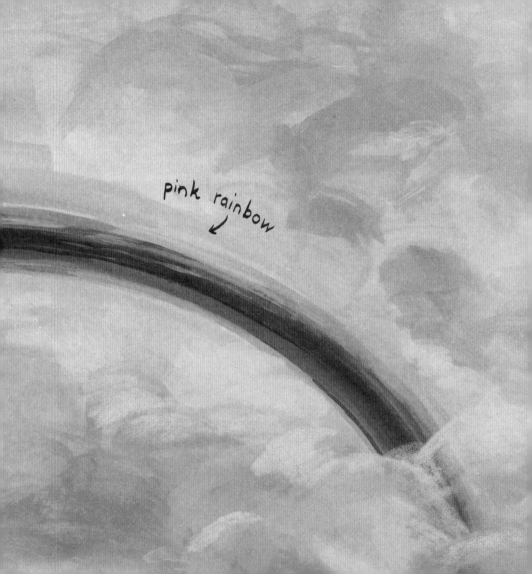

pink rainbow

Even as we have perfected the practice of predicting eclipses, their viewing has retained an element of incalculability, in that we still can't really predict earthly weather—not enough, anyway, to plan with certainty where one can view an eclipse. People will travel thousands of miles (really) to view a total solar eclipse, only to have their carefully laid plans dashed by a few minutes of cloud cover. Not all is lost, though: under certain rainy conditions, an all-pink rainbow can form in the light of the eclipse.

Note that lunar eclipses also have been transformed in the public imagination from frightening omens to points of interest. But since they are easily seen from any point on Earth that's in darkness, traveling around the world to see one is neither relevant nor necessary.

ECLIPSE TECH

Today, with a smartphone in nearly everyone's pocket, we are equipped with access to technology that would have astonished eclipse viewers of centuries past. While our relationships with our smartphones may be fraught, some of the best value they can ever offer us is their ability to increase access to a phenomenon such as a total solar eclipse. Our phones can give us all kinds of terrestrial information to help us more exactly pinpoint where to set up for a viewing session. And depending on location and service, you also have up-to-the-moment information on weather and the all-important variable of cloud cover. Once you're in totality, you might make use of one of numerous star map apps, which automatically align themselves to your orientation and provide location-specific information about which planets you're seeing, which stars, what constellation they belong to, and more. But with this great power must also come a serious warning—do not let your phone distract you from the ephemeral and fleeting main event. Information can add to our experience of a natural marvel to a threshold, but we should never let it intrude on the wonder of the direct experience.

Missing the main event is a concern in any eclipse documentation. Totality passes quickly—it usually lasts only a few minutes and never more than about seven minutes. Viewers confirm that this time seems

to fly by. Be that as it may, it's a natural urge to try to record what you're witnessing. Eclipse photography is its own specialized world, with its own guides packed with information on the best lenses, cameras, and telescopes to use for photographing and observing eclipses, along with stringent guidelines on the best ways to transport your tech to the site of totality. If you're a photographer, totality is a special opportunity to capture a rare event. The rest of us might try a more basic and nonvisual option that lets us keep our eyes on the main event: an audio recording. You can use a tape recorder or your phone's audio recording app to record your own narration—describing what you see but also how you feel, how the temperature changes, what other differences in sight and sound you notice—anything that comes to mind (and the oohs and aahs of anyone present). You'll have a concrete record of totality without looking away once.

Partial eclipses—and partial phases of any solar eclipse—last longer and give you more time to observe. This is a great time to bring out your pinhole camera. You might set up a large sheet of white paper on the ground and trace the pinhole image of the sun as the eclipse progresses. Or look for natural pinhole effects to photograph or draw.

OTHER SUN PHENOMENA

Though not related to eclipses, a number of other solar phenomena bear mentioning for the enthusiasm they generate in viewers. Atmospheric refraction near the horizon can produce a **green flash**, a phenomenon in which a spot of green light appears to hover above the sun just as it sets. **Mock suns**, sometimes called **sun dogs**, are a **halo effect**, occurring as a result of the refraction of sunlight by the atmosphere. Sun dogs are best seen from the middle latitudes of Earth. **Solar pillars**, which appear occasionally as beams of light reaching vertically from the sun, are another type of halo effect.

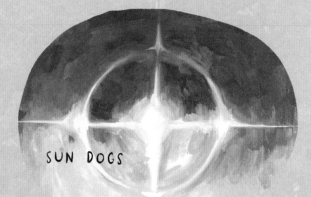

SUN DOGS

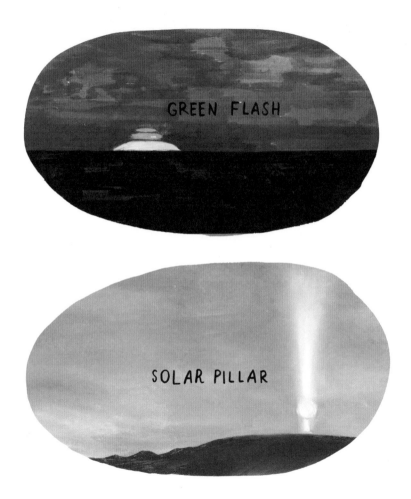

GREEN FLASH

SOLAR PILLAR

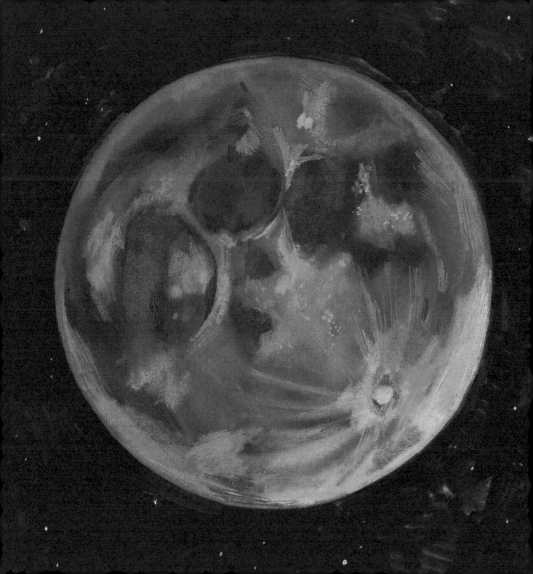

LUNAR ECLIPSES

Lunar eclipses sometimes stand in the shadow (so to speak) of solar eclipses, mostly because they aren't quite as dramatic, and they don't cast an extreme shadow of influence onto the Earth. In a lunar eclipse, the sun creates a shadow of the Earth over the moon, not the other way around. But lunar eclipses have their own visual majesty, a phenomenon well worth observing and even celebrating.

Aside from the mechanisms by which they take place (namely, the different relative positions of the sun, moon, and Earth), important aspects of lunar eclipses that set them apart from solar eclipses are their global relevance—they can be seen from anywhere on Earth, as long as it's nighttime—and the ease with which we can view them—they last longer, so they are harder to miss, and they require no safety precautions to view.

We see the shadow of the Earth projected onto the moon during a lunar eclipse. A round edge is visible to any observer. The shadow is round because the Earth is round. Early astronomers caught on to this. What's more, the curvature of the shadow always looks the same, which wouldn't be possible if the Earth were a flat disk. The only shape that could consistently cast a round shadow is a sphere—indisputable proof that we live on a spherical planet.

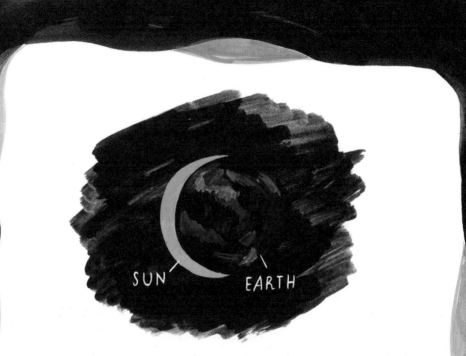

SUN EARTH

While we're seeing a lunar eclipse from the Earth, an observer on the moon would see a partial or total solar eclipse: The Earth either partially or fully eclipses the sun from the moon's viewpoint, so the observer standing on the moon would see the sun disappear behind the Earth at the same time terrestrial viewers see the Earth's shadow cast onto the moon.

TYPES OF LUNAR ECLIPSES

Lunar eclipses fall into three categories: total, partial, and penumbral. These eclipses are different from solar eclipses because rather than another celestial object transiting or occulting the moon from our view, we are simply seeing the shadow of an object—our own Planet Earth—cast onto the moon. Recall the two types of shadows cast by an object: the dark central shadow of the **umbra** and the diffuse outer shadow of the **penumbra**. These account for the different types of lunar eclipses.

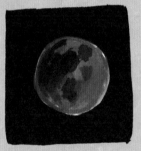

TOTAL

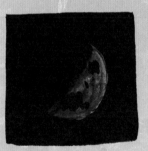

PARTIAL

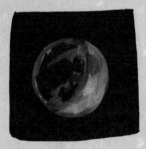

PENUMBRAL

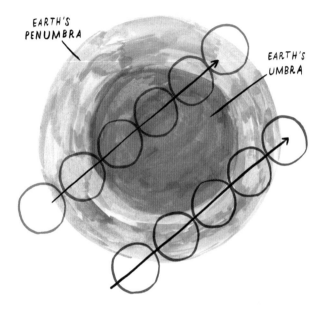

Both the Earth's atmosphere and its spherical form account for the blurriness of its shadow on the moon. In a total lunar eclipse, for a variety of reasons, the moon can turn red in this shadow, earning the popular name **"blood moon."** Earth's shadow cast onto the moon can reflect terrestrial conditions; sometimes major volcanic eruptions throw so much dust into the atmosphere that it alters the shadow the Earth casts onto the moon during an eclipse.

CONTACT IN LUNAR ECLIPSES

As in solar eclipses, we speak of contacts in lunar eclipses. **First contact** in a lunar eclipse occurs the moment a penumbral eclipse starts, when the penumbral shadow of the Earth first makes contact with the edge of the moon's disk. **Second contact** begins when the darker umbra shadow of the Earth first makes contact with the edge of the moon's disk. **Third contact** is the start of a total lunar eclipse, when the umbra of the Earth first fully obscures the disk of the moon. **Fourth contact** is the end of the total phase, when the umbra no longer fully occludes the moon. **Fifth contact** is the moment the umbra leaves the disk of the moon altogether. Finally, **sixth contact** is the moment the penumbra leaves the disk of the moon altogether.

FIRST CONTACT SECOND CONTACT THIRD CONTACT

FOURTH CONTACT FIFTH CONTACT SIXTH CONTACT

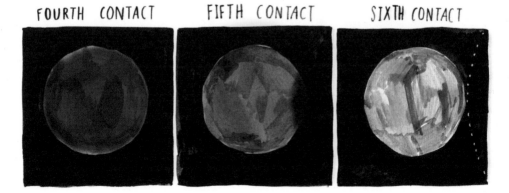

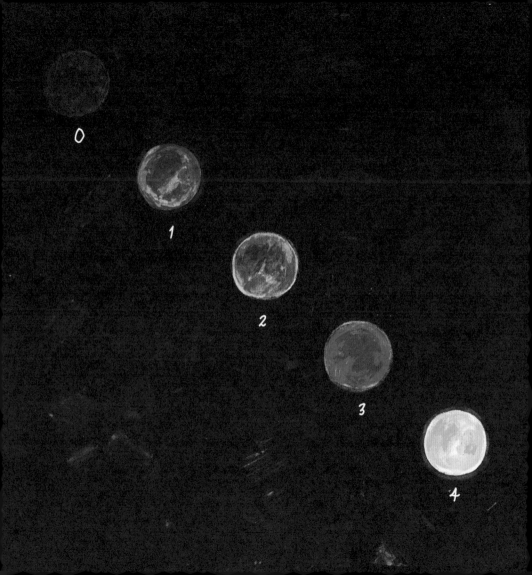

DANJON SCALE
of LUMINOSITY

In the 1920s, the French astronomer André-Louis Danjon introduced a metered scale for judging the moon's luminosity during a total lunar eclipse. The Danjon scale was designed to be used in naked-eye observations, giving citizen scientists the opportunity to record their observations of eclipses alongside timings and specific locations. The differences in the luminosity of the moon throughout a given lunar eclipse based on location, as well as the differences across multiple eclipses, are of interest both to science and to the lay astronomer. You could make it a project to record your own Danjon observations over a particular total lunar eclipse and compare them to the numbers of a friend or family member observing from another point on the Earth. (Note that it's unlikely any of your measurements will match the Danjon options exactly—decimal points are allowed and even encouraged.)

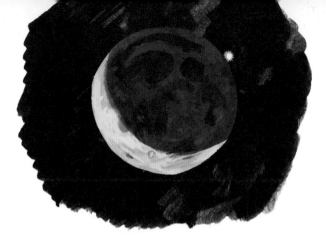

LUNAR OCCULTATIONS

An occultation occurs any time a large object in the sky moves in front of and blocks—occults—a smaller object. (Sizes here refer to their apparent size in the night sky, not the actual sizes.) Full moon occultations of stars are not usually notable, since the brightness of the full moon outshines the small dot of the star and makes the moment of contact hard to see. However, during a lunar eclipse, when the disk of the full moon is darkened, the occultations of stars are much more noticeable. Timing the occultation of specific stars by the moon—and the time it takes them to reappear on the other side—is one way to chart the character of a given eclipse. You can use a printed star map or augmented reality star mapping app to determine which stars you are looking at during a lunar eclipse.

ANTARES

Antares, a bright star known to many ancient civilizations, was discovered to actually be a binary star system during a lunar occultation, once telescopes became available to astronomers. Instead of revealing one bright star at the end of occultation, the moon inched over to reveal a star of less than usual brightness for Antares; as the moon continued to move, the star seemed to grow in brightness. The star system is too far away to discern it as two separate bodies, but the occultation revealed their duality for a brief moment.

SELENELION

Specific conditions can allow for a phenomenon called **selenelion**, also known as a **horizontal eclipse**, in which a viewer can see both the lunar eclipse taking place in front of them and the sun setting behind them. To see a selenelion, you must be in a spot on Earth where a lunar eclipse is taking place right at moonrise or moonset. The way light bends—**refraction**—makes this possible. Even though one or both of the sun and moon may be below the horizon at the moment of eclipse, refraction can make them both briefly visible.

THE
SUN

THE
EARTH

THE
MOON

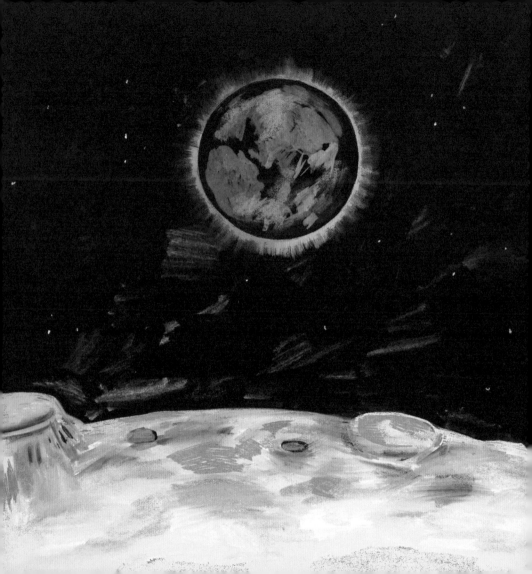

OTHER ECLIPSES

Lunar and solar eclipses captivated the ancients and captivate us still, but they have cousins that have more recently become objects of our awe. These are the "other" eclipses, the ones that aren't so obvious to our naked eyes on Earth but arise from the same physical principles.

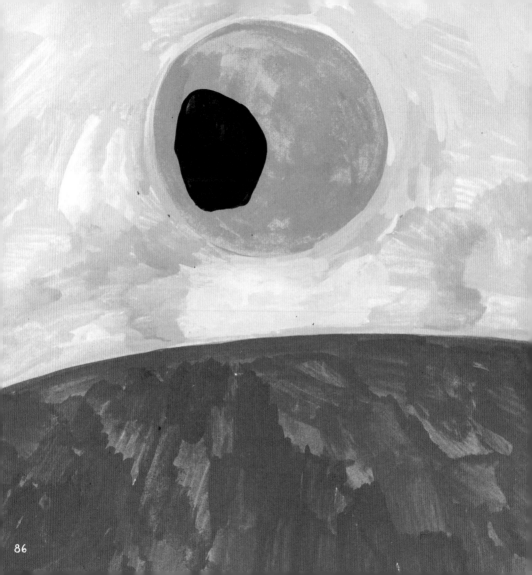

ECLIPSES FROM MARS

Mars has two moons, Phobos and Deimos. They are smaller than our moon (and Mars is also farther from the sun), so an occulting eclipse doesn't really happen from Mars. But back on Earth we've still watched with glee as multiple Mars rovers have photographed transits of Phobos across the disk of the sun. Beyond the novel idea of a Martian eclipse, this documentation is actually scientifically useful, as it allows closer study of the way Phobos orbits Mars over time.

OTHER TRANSITS & OCCULTATIONS

The English astronomer Edmond Halley developed a technique (based on work by the Scottish mathematician James Gregory) that could use transit times to determine the relative distances of the inner planets from the sun. Galileo used the regular occultation of the Jovian moon Io as a kind of clock; Io's orbit was so reliable that it could be used to calculate longitude on Earth. Even today, eclipses continue to enable new discoveries about the night sky.

the
"BLACK DROP"
effect

The study of the inner planets transiting the sun
is complicated by the **black drop effect**, a visual
phenomenon in which the disk of the body
appears to stretch into a teardrop shape just as
it starts to traverse the solar disk.

APPEARS BRIGHTER
WHILE UNECLIPSED

Eclipsing binary stars—dual star systems
in which one star periodically eclipses the
other, blocking its light and making the star
system appear dimmer—can be studied
based on their eclipses.

APPEARS LESS BRIGHT
WHILE ECLIPSED

THE PLANET VULCAN

The term *planet* comes from an Ancient Greek word meaning "wandering star"—the motion of the planets as viewed from Earth looks different from that of the rest of the "stars" in the sky. We can explain this once we understand that the sun is at the center of our solar system, with Earth and the other planets orbiting around it. Of the seven non-Earth planets in our solar system, five have been known since antiquity, as they are visible to the naked eye: Mercury, Venus, Mars, Jupiter, and Saturn.

In 1781, the planet Uranus was discovered, the first to be spotted with a telescope to augment the naked eye. This gas giant was thrilling to astronomers, but puzzling as well: As they mapped this new discovery over the following decades, it became clear there were irregularities in the orbit of Uranus around the sun. The math indicated there could be another large body nearby impacting its neighbor's movement. Astronomers started looking for another planet orbiting the sun beyond Uranus, and they found it: The outer planet Neptune was the first planet discovered purely by using math.

So science had just discovered a planet orbiting *outside* every other known planet, one that was invisible to the naked eye. What if there was something similar orbiting *inside* the orbit of every other known planet, made all but invisible due to its proximity to the sun?

Observations of Mercury (the closest planet to the sun) had always left some questions—it was often impossible to fully explain the position of the planet using Newtonian physics alone. And because Mercury orbits so close to the sun, it's harder to observe from Earth (whenever we face it, it is daytime, since facing Mercury means facing its nearby neighbor, the sun). Occasionally the orbit of Mercury around the sun will lead it on a path between the sun and the Earth, during which it appears as a tiny dot traveling across the disk of the sun. Unlike during an eclipse, these transits of Mercury across the sun do not noticeably reduce the amount of light and heat hitting the Earth, so we don't notice them unless we're looking for them.

Astronomers in the nineteenth century started searching for a hypothetical "intramercurial" planet they called Vulcan, after the Roman god of fire. Some thought they'd glimpsed it in transit across the sun (though these observations were probably of sunspots). Others believed they observed it during total solar eclipses. Its existence was never conclusively proven—because it never existed.

In 1919, a solar eclipse took place that settled that question once and for all. This was the eclipse during which Einstein's theory of relativity was proven, as Einstein's math perfectly predicted the position of Mercury observed in the eclipse. Einstein and other scientists had been researching general relativity for many years prior to this event, but it took that solar eclipse to truly cement the theory in the scientific community and in the public consciousness.

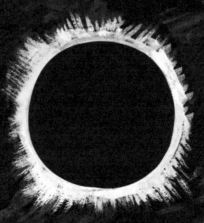

CONCLUSION

The strange coincidence of the eclipse has captivated humans since we first observed the stars. First frightened and confused, then curious, we have now become adept at understanding the sky. More and more of us are comfortable with them, and indeed thrilled to observe these fascinating phenomena. Perhaps the scientific usefulness of solar and lunar eclipses has been fully plumbed, but the wonder of the spectacle will still go on for millions and millions of years.

RESOURCES

Five Millennium Catalog of Solar Eclipses + Five Millennium Catalog of Lunar Eclipses: NASA keeps a catalog of five millennia (2000 BCE to 3000 CE) of both solar and lunar eclipses. This includes the categorizations, dates and times, locations, saros numbers, phase durations, and more for every single eclipse within that five-thousand-year period. Find the catalog at eclipse.gsfc.nasa.gov.

Your nearest science museum: Since solar eclipses are geographically tethered, local institutions are a great resource. If you have a local planetarium or science museum, ask if they have eclipse resources such as protective eyewear and educational materials.

Star maps: People have been making star charts for centuries, so they're easy to find—and in the last decade or so, technology has advanced to the point of bringing us handheld planetariums customized to our location and geographic orientation, in the form of smartphone apps. A current favorite is Stellarium, a beginner-friendly program available in your browser but also as an app—it creates an interactive and dynamic map of the sky in any direction you point your phone toward.

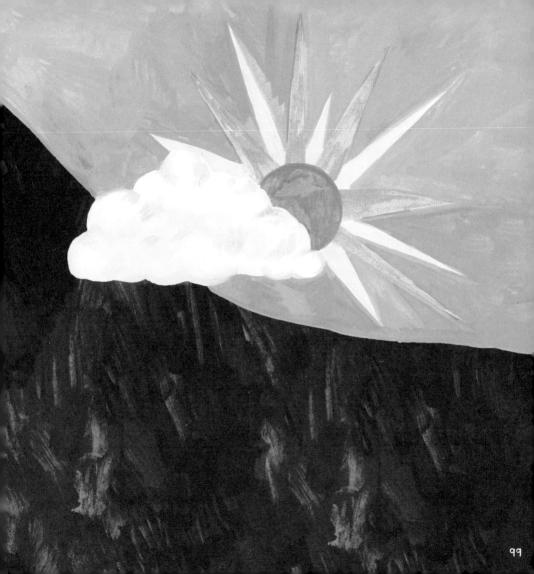

ACKNOWLEDGMENTS

The biggest thank-you to my expert editor, Kaitlin Ketchum, for making this book happen, along with the rest of the team at Ten Speed Press, including designers Betsy Stromberg and Nicole Sarry, production editor Ashley Pierce, and production manager Claudia Sanchez. Thanks also to Diane Borsato for sparking something new in me, reinviting me to look at natural wonders with awe. And thanks to Nick and Aiden, for everything.

ABOUT THE AUTHOR

Kelsey Oseid is a writer and illustrator. When she isn't painting, she enjoys sewing, knitting, baking, and going on long walks. She lives in Minnesota with her husband and son.

INDEX

Published in the United States by Ten Speed Press, an imprint of the Crown Publishing Group, a division of Penguin Random House LLC, New York.
TenSpeed.com

Ten Speed Press and the Ten Speed Press colophon are registered trademarks of Penguin Random House LLC.

Typeface: Latinotype's Aestetico

Library of Congress Cataloging-in-Publication Data

Names: Oseid, Kelsey, author.
Title: Eclipse / Kelsey Oseid.
Description: First edition. | [Emeryville, California] : Ten Speed Press, [2024] | Includes index.
Identifiers: LCCN 2023003214 (print) | LCCN 2023003215 (ebook) | ISBN 9781984859464 (hardcover) | ISBN 9781984859471 (ebook)
Subjects: LCSH: Eclipses--Popular works.
Classification: LCC QB175 .O84 2024 (print) | LCC QB175 (ebook) | DDC 523.9/9--dc23/eng20230727

LC record available at https://lccn.loc.gov/2023003214
LC ebook record available at https://lccn.loc.gov/2023003215

Hardcover ISBN: 978-1-9848-5946-4
eBook ISBN: 978-1-9848-5947-1

Printed in China

Editor: Kaitlin Ketchum | Production editor: Ashley Pierce
Editorial assistant: Kausaur Fahimuddin
Designers: Nicole Sarry and Betsy Stromberg
Production manager: Claudia Sanchez
Copyeditor: Kristi Hein | Proofreader: Sasha Tropp
Publicist: Erica Gelbard | Marketer: Chloe Aryeh

10 9 8 7 6 5 4 3 2 1

First Edition

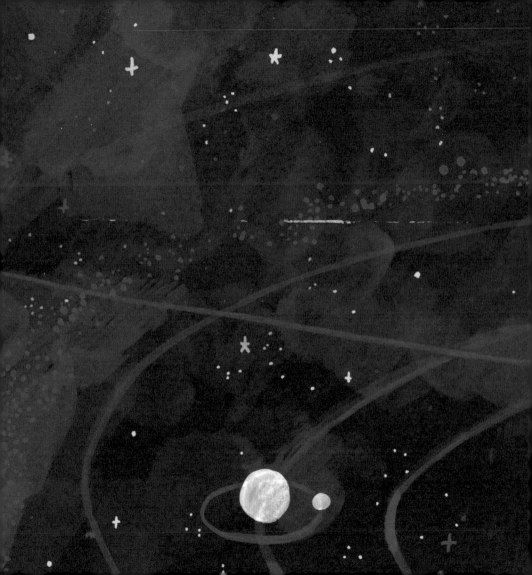